This is me: living with Asperger's is a photo documentary series by photographer Kerry Gerdes. In 2013 Kerry Gerdes was diagnosed with Asperger's syndrome. Since then she has developed this autobiographical project based on her own life. This is the first book in the series, which as her condition, will be a lifelong one.

Kerry Gerdes is a photographer from Plymouth, Devon. Her work has been exhibited across the UK as well as in the USA.

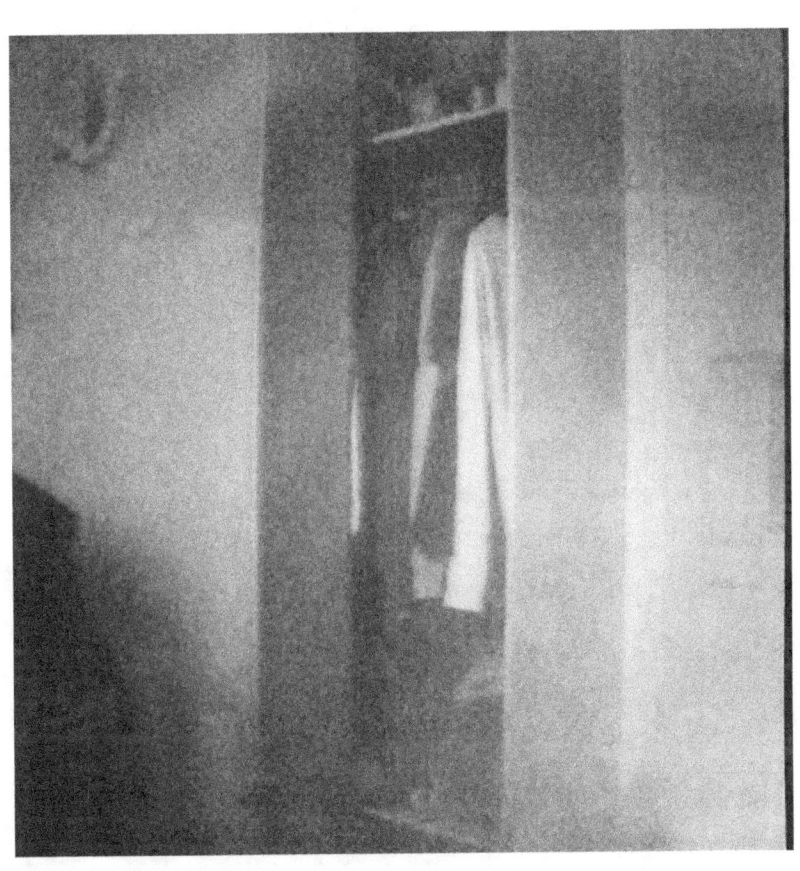

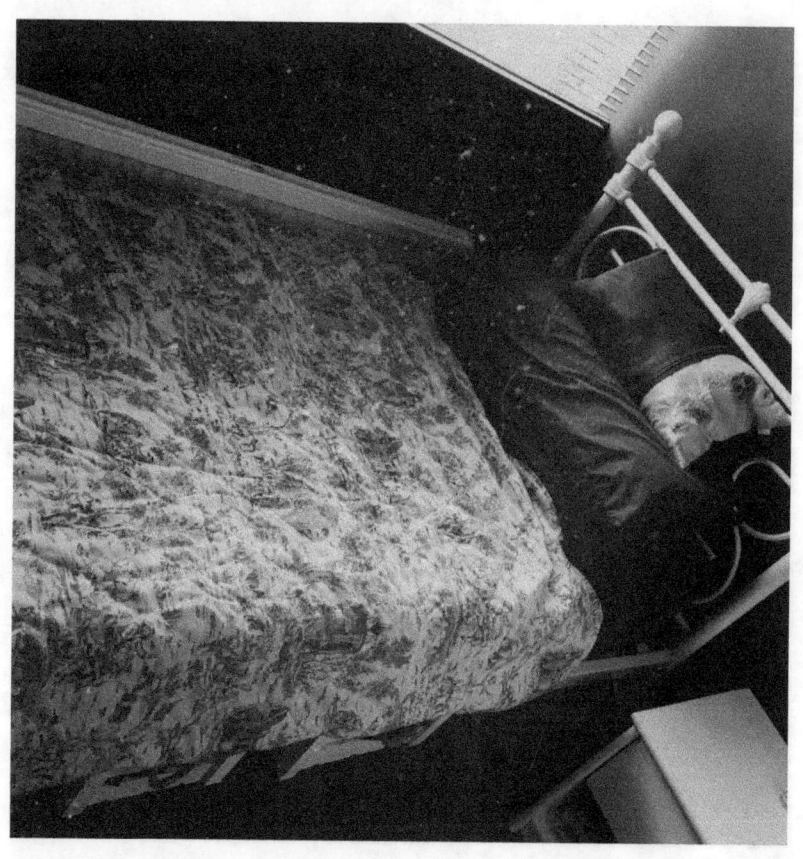

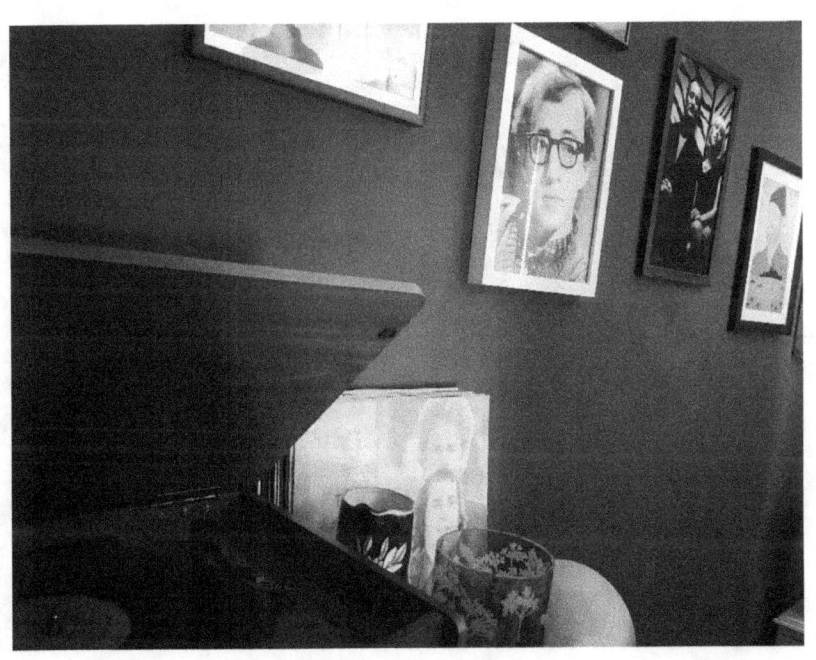

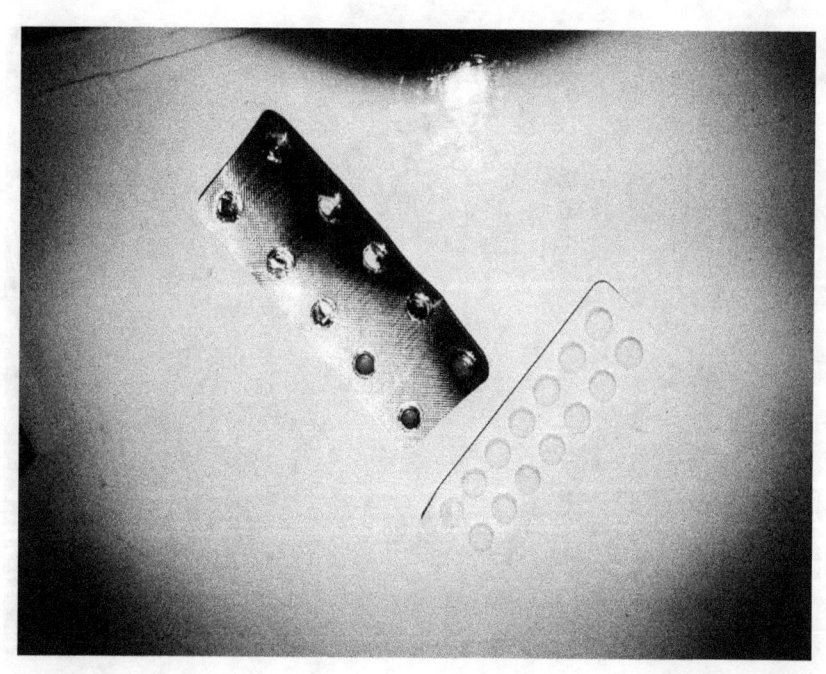

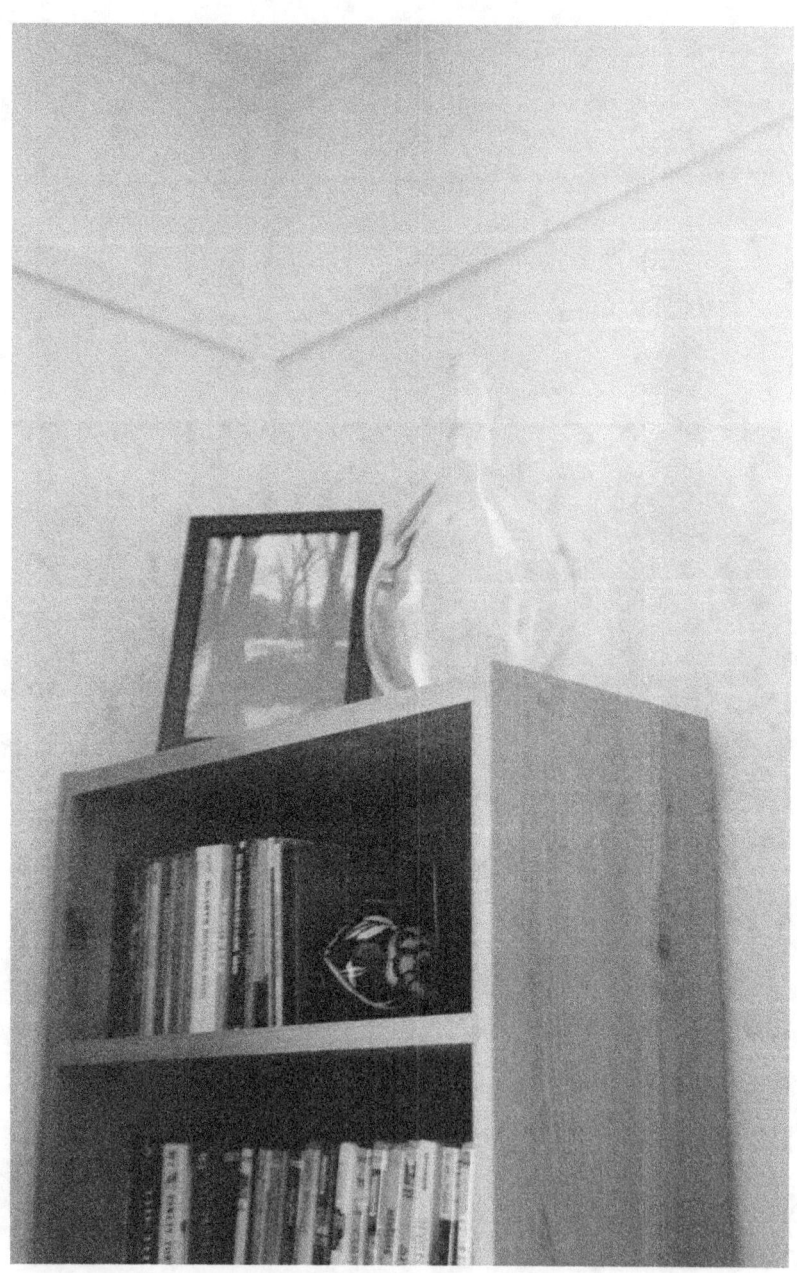

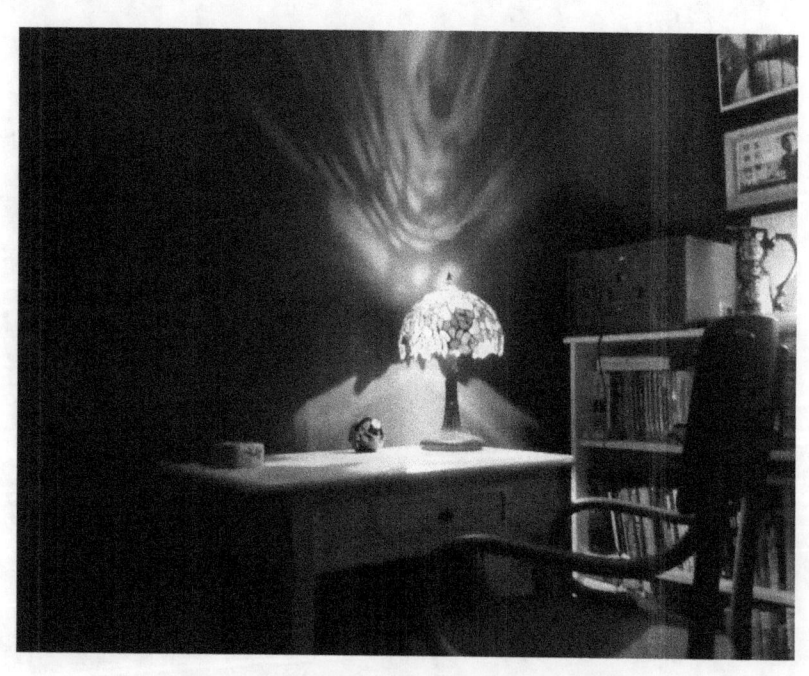

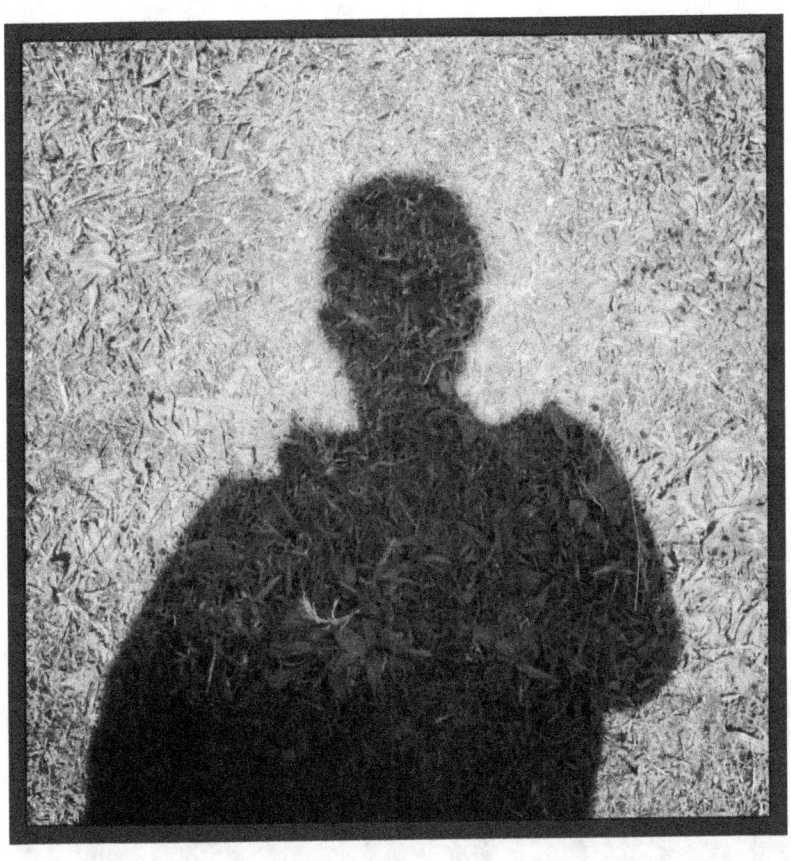

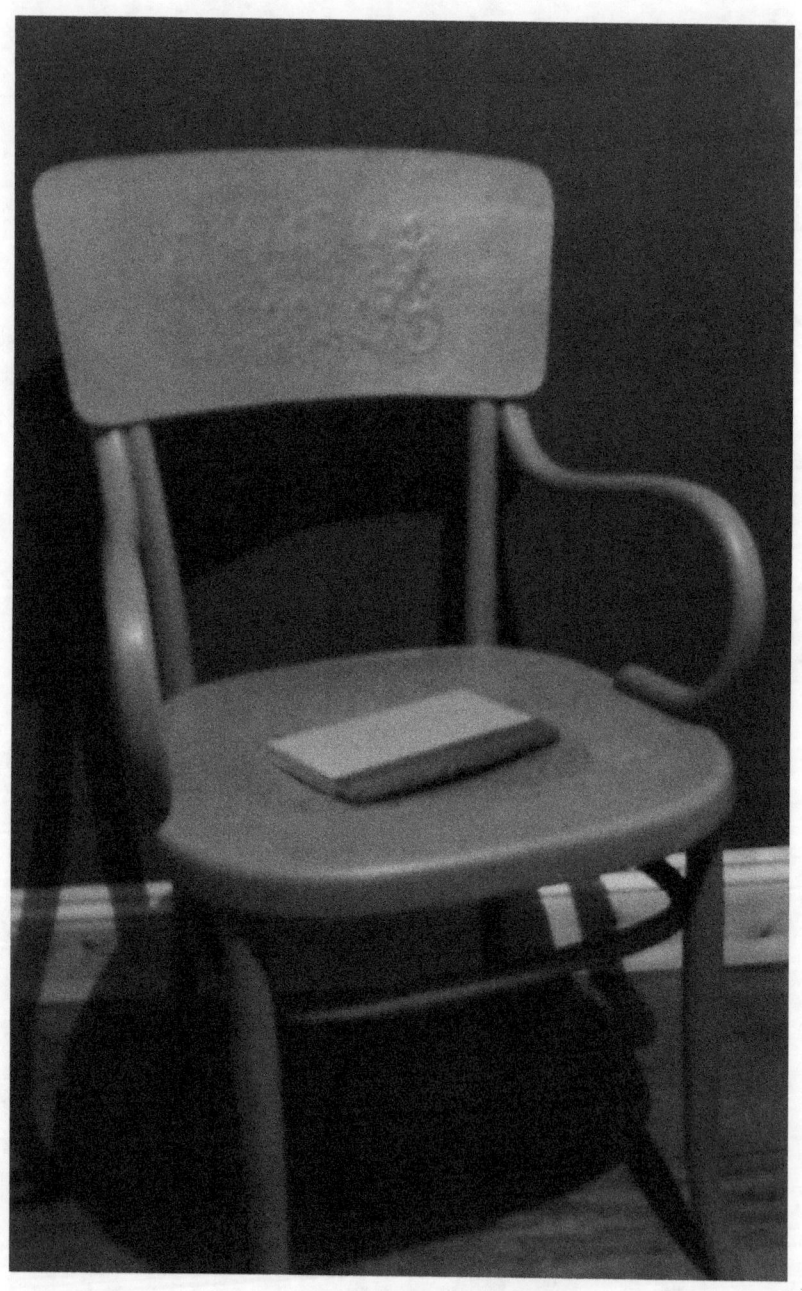

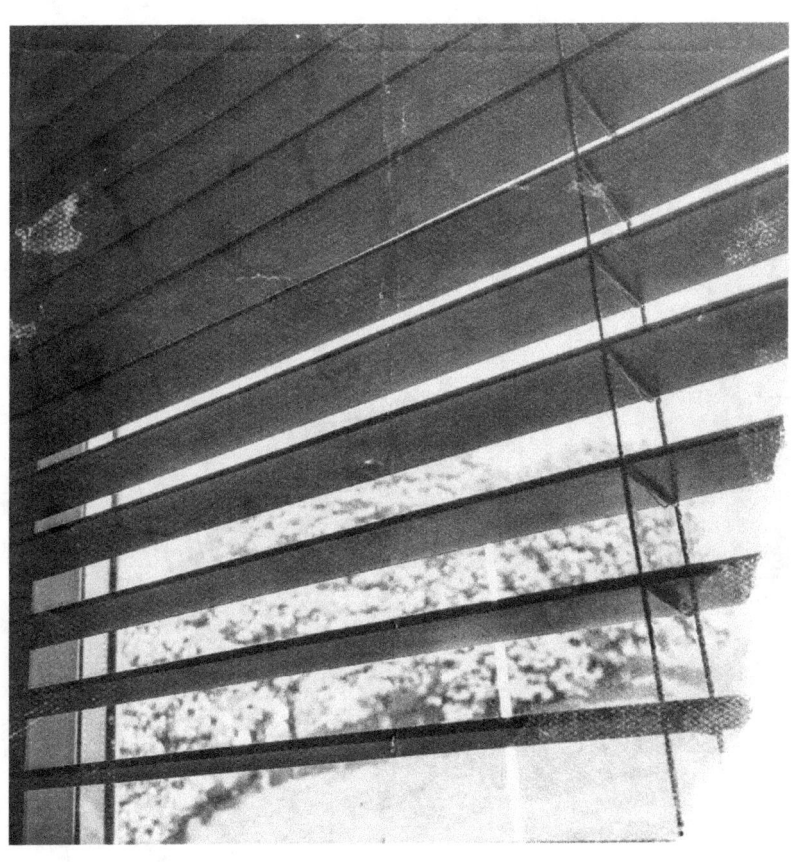

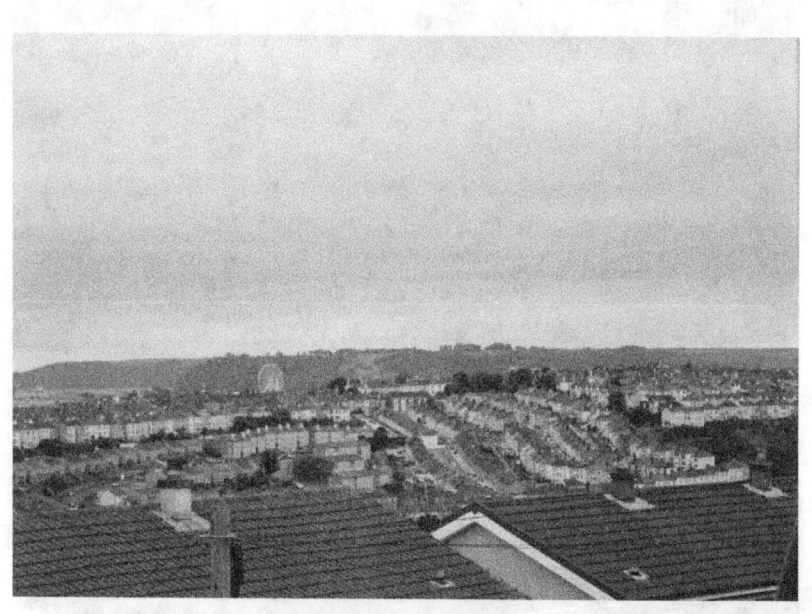

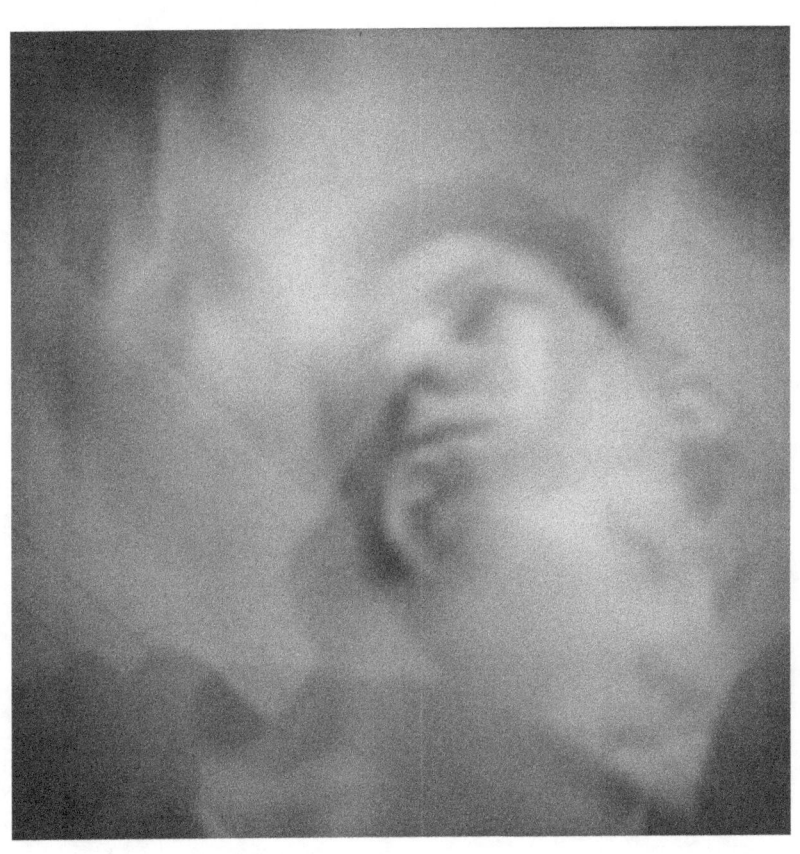

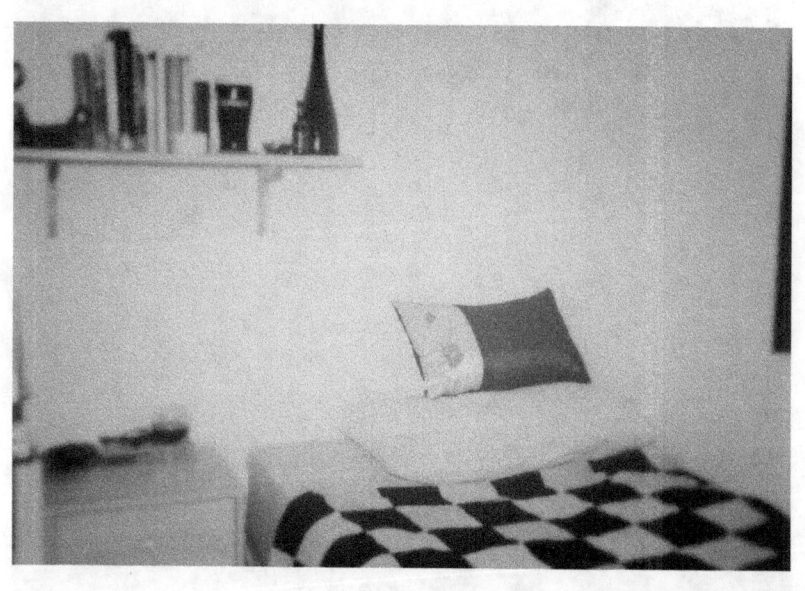

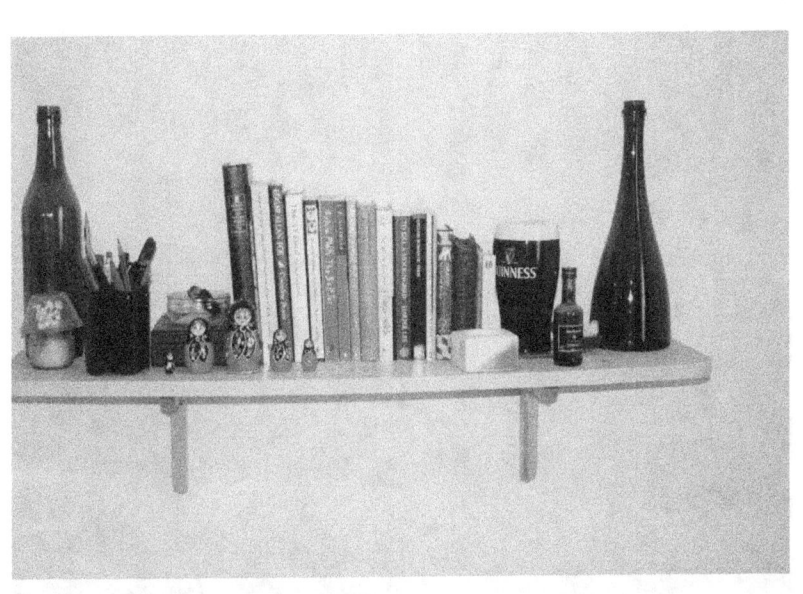

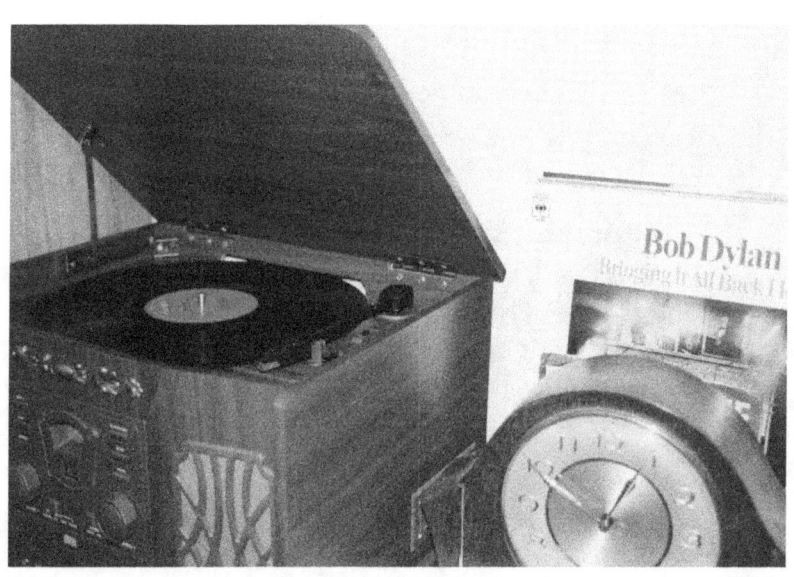

www.ingramcontent.com/pod-product-compliance
Lightning Source LLC
Chambersburg PA
CBHW070434180526
45158CB00017B/1261